BP
PORTRAIT
AWARD
2013

National Portrait Gallery

Published in Great Britain by
National Portrait Gallery Publications
National Portrait Gallery
St Martin's Place, London WC2H 0HE

Published to accompany the BP Portrait
Award 2013, held at the National Portrait
Gallery, London, from 20 June to 15
September 2013, Aberdeen Art Gallery
from 2 November 2013 to 1 February 2014
and Wolverhampton Art Gallery from
3 March to 14 June 2014.

For a complete catalogue of current
publications please write to the address
above, or visit our website at
www.npg.org.uk/publications

ISBN 978 185514 462 0

A catalogue record for this book is
available from the British Library.

10 9 8 7 6 5 4 3 2 1

Managing Editor: Christopher Tinker
Project Editor: Andrew Roff
Design: Anne Sørensen
Production: Ruth Müller-Wirth
Photography: Prudence Cuming
Printed and bound in Italy
Cover: *Heterochrome – Fraser & his
self-portrait* by Greg Kapka

Supported by BP

FSC
www.fsc.org
MIX
Paper from
responsible sources
FSC® C016114

CONTENTS

This year, 2013, marks a number of changes to the National Portrait Gallery's *BP Portrait Award*, made possible by the generous continuing support of BP for a further five years – including the increase in the first prize award to £30,000. As in other years, the winning artist will be invited to undertake a portrait for the Gallery's Collection. Susanne du Toit has demonstrated, with her outstanding painting of a seated young man, a beautifully constructed simplicity and directness of approach, which brought all the judges to agreement that this should be the overall winner. The runner-up, an ambitious group portrait of three artfully arranged young subjects by John Devane, was greatly admired, as was *Das Berliner Zimmer (The Berlin Room)* by Owen Normand, the winner of the 2013 Young Artist Award. This year the 2012 BP Travel Award winner, Carl Randall, is displaying his fascinating work, painted while making an extended visit to Japan.

Although the three prizewinning paintings stood out, they were part of a close debate relating to a dozen or so of the most successful works, which had emerged during the process of selecting the fifty-five exhibited works from among the 1,969 entries. The impact of a successful portrait can be immediate or emerge through the various stages of the judging process, which was undertaken, as always, without any knowledge of the artist's name or nationality. Whatever the approach or style, the individuality of the sitter or sitters portrayed must show through.

Entries were received from seventy-seven countries, and the increasingly international character of the competition is matched by the growing number of overseas visitors to the exhibition at the National Portrait Gallery. Many of these will also admire the work of young people who have taken part in the BP Portrait Award: Next Generation project, and some will register their own view through the Visitors' Choice facility and perhaps also take part in the Family Activities, illustrated this year by Anna Hymans. All this makes 2013 a year in which the art of portrait painting can be further admired and celebrated.

BP's renewed sponsorship of the competition, the exhibition and the Travel Award – offers further support for artists in extending this exceptional arts partnership. The National Portrait Gallery is very grateful to Des Violaris, Ian Adam, Peter Mather and other colleagues at BP, as well as to Bob Dudley, Chief Executive.

Director, National Portrait Gallery

SPONSOR'S FOREWORD

Why should a global company support an art award? The answer may not be obvious, but in fact there are many reasons.

Firstly it is about excellence. That is something BP aspires to, and that is also seen in the BP Portrait Award. The artists inspire us by the way they strive to achieve perfection in capturing the character of their subjects.

Secondly, the competition is a celebration of diversity, which resonates with BP's aspiration to welcome people from all backgrounds and cultures.

Third, the competition has expanded to become truly global, mirroring BP's own journey.

Fourth, the competition reaches many people, giving us a connection with the societies in which we work, and finally, and most importantly, the pictures remind us that every individual is unique.

Our success in BP depends on recognising each employee's uniqueness, as well as bringing individuals together to accomplish energy projects that no-one could achieve alone.

Our thanks go to Sandy Nairne, Pim Baxter and the team at the National Portrait Gallery for their professionalism and dedication. I would also like to acknowledge BP's appreciation for all the artists who have entered the BP Portrait Award, and applaud the winning artists for their spectacular and inspirational work.

Bob Dudley
Group Chief Executive, BP

Remember Me

Joanna Trollope
Novelist

We have worked out, really, why we all love looking at portraits. We are, unsurprisingly, fascinated by looking at our own kind, and every time, from babyhood onwards, that we see another face, we experience a sort of recognition. And, it seems, this recognition applies as much to faces that have been drawn and painted – by the owners of other faces – as it does to ones that we pass in the street.

So this gallery – and in this instance, this exhibition – draws people in with a particular intimacy. Whether we respond with enthusiasm or revulsion to various artistic interpretations of the human face, we always *respond*, in some way. Portraits, as a genre, don't leave us cold. They are depictions, and expositions, of something fundamental to all of us, our shop windows to the world, if you like: our faces.

But what, I wonder, are the feelings, or even the motives, of the *sitters* for all those portraits – over a thousand of them on display at any one time in this gallery? What is it that makes people want to sit for a painted portrait – often a lengthy and laborious business, even in these days of photography – rather in the same yearning way that makes people long to write a published novel? And not only that, but has the motivation changed down the years, as the iconography of the

ages, and their codes of conduct, inevitably shift?

It's tempting, always, to go back for examples to the compelling Tudors. But I'm going to restrain myself. In this quest for the impetus behind the personal, rather than social or cultural, reasons to sit for a portrait, I'm going to start with the Restoration, and, most particularly, with Sir Peter Lely and Barbara Villiers, Duchess of Cleveland. There is, as they say, a history here. Barbara Villiers, well born but impoverished, and unquestionably gorgeous in the voluptuous, lavish, dark mode of the day, had met the young Charles II when she was only eighteen. She married the slightly chinless Roger Palmer, later Earl of Castlemaine, a year afterwards, but by then she was already established in her major life role, that of chief mistress to the young and newly restored King, by whom she had five children.

Not only was Barbara Villiers married, but so was the King. She had doubtless married for money and security, and he had married, for dynastic reasons, Catherine of Braganza – quiet, devout and possessed of a sizeable dowry – who was not only mocked for her antiquated Portuguese court dress when she first arrived, but who also somewhat naturally objected to the King's taking such a flamboyant and formidable mistress.

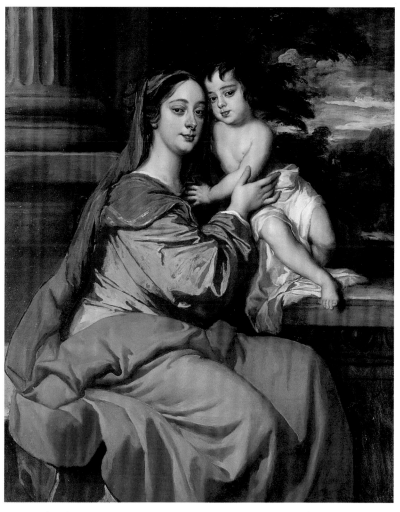

Barbara Palmer (née Villiers), Duchess of Cleveland (1640–1709) with her son, Charles Fitzroy, as Madonna and Child by Sir Peter Lely, c.1664 (NPG 6725)
Oil on canvas, 1247 x 1020mm

So, we have quite a plot here. Two young couples, several different moral codes (or none at all), power, a new and excitedly hedonistic court, public opinion, private anguish, beauty and sex – everything, indeed, that the most rapacious modern tabloid could desire.

And so, in 1664, when she was twenty-four, Barbara Villiers sat yet again – deliberately, one can't help thinking, for this particular

portrait – for the Court painter, Sir Peter Lely. She was not only Lely's publicly confessed muse, but also the epitome of contemporary female good looks. She was in addition aware of the tightrope she walked in public opinion, and so, in this portrait, she displays a confidence that almost amounts to arrogance in allowing herself to be portrayed to all intents and purposes as the Virgin Mary, dressed in the traditional sweeping blue mantle over a coral red robe, and holding – or, rather, decorated by – a sumptuous toddler, who might stand in for Christ, or might just hint, wickedly, at Cupid.

So, what is she saying in this magnificent painting? She is saying, it seems to me, that she is perfectly, utterly secure in the King's affections, and that he adores their children as much as she does. She knows Catholicism is extremely important to many people as well as to the King, but is sufficiently confident to be daringly disrespectful of it. And what she is also saying, from the pinnacle of her youth, fertility and hold over the King, is that she doesn't care, and she equally doesn't care who knows it. The painting is her statement to the world – you can't touch me.

How different, and how different the attitude of the sitter, from another portrait of a hundred years later. A second young woman, another famous painter – George Romney this time – but a world away from that pleasure-loving seventeenth-century court. Mary Moser, one of the foremost flower painters of her day – she won her first medal for it when she was fourteen – was the daughter of an artist and enameller. She was also

a dedicated professional and in 1768 was among the founders of the Royal Academy at the age of twenty-four (along with only one other woman, Angelica Kauffmann).

Two years later, she sat – or rather stood – for her portrait by George Romney. She is painting a still life of fruit and foliage, and she has half turned, with a slightly bent head, to look at the viewer. She is in a vermilion draped garment, over grey blue, all rather artlessly classical, and her dark hair is casually bundled up in a fillet, presumably to get it out of the way. She wears no jewellery and no cosmetics, and although her expression isn't solemn, it isn't smiling either. She looks like someone who has agreed to be painted by a master of the day because it will serve to advertise this new academy, but actually, being interrupted in her work is something of an inconvenience – 'I will do this,' she seems to be saying, 'because it will help the Academy. And possibly the emancipation of women. But ….' Why do I mention emancipation? Because the writer, feminist and mother of Mary Shelley, Mary Wollstonecraft was a contemporary, in a relatively small circle of cultural influence. And John Opie's portrait of her was painted a mere seven years later (the year of Wollstonecraft's death at only thirty-eight), and it is very much in the same direct, unadorned style. It is significant that after Mary Moser died, in 1819, there were no further full female members of the Royal Academy until Dame Laura Knight, in 1936. Portraits such as these two have the evident intention of conveying the sitter's cultural or social message to the world, rather than an

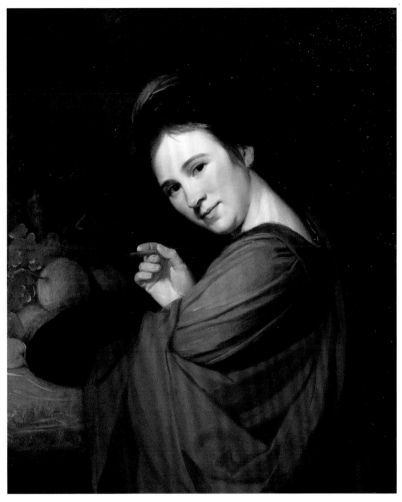

Mary Moser (1744–1819) by George Romney, c.1770–1 (NPG 6641)
Oil on canvas, 763 x 642mm

egoistic message about themselves. Someone like William Wilberforce, in the following century, would take that determination even further. He was a hero, of course, to his own times as well as to posterity, but he was not known for his interest in art, nor for any personal enthusiasm for being painted. The wonderful unfinished portrait of Wilberforce by Sir Thomas Lawrence is a perfect example of a sitter who has presumably been persuaded to sit for a painting because his achievements merit it and because the public longs to see the great man immortalised

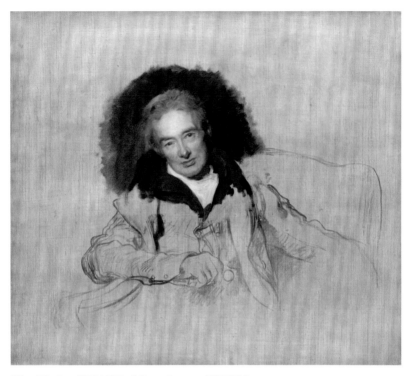

William Wilberforce (1759–1833) by Sir Thomas Lawrence, 1828 (NPG 3)
Oil on canvas, 965 x 1092mm

on canvas, but who can't himself see either the point or the need for it. The painting has, in fact, an extra energy for being unfinished. It was started in 1828, five years before Wilberforce's death. Only the head and shoulders and a small halo of background are painted, the rest is just charcoal sketching. Wilberforce looks as if he has whirled into a chair, and is only going to be there for a moment, his face lit up by the reflection from a white cravat, and his glance revealing the greatest humanity and intelligence. There is no vanity or self-regard in his expression or in his pose. He is a sitter who has

been told that he has to sit, for the benefit of millions of admiring people, whatever he feels about it himself. But he is impatient to be gone. And he has little truck with what, in modern parlance, would be called 'image'.

Looking at the twin portrait of Peter Pears and Benjamin Britten, painted in 1943 by Kenneth Green, it is plain that Britten at least had even less idea of the possible interpretation of image. Rather like William Hilton's poignant painting of the poet John Clare – commissioned by the latter's publisher, and beautifully sympathetic and private in mood –

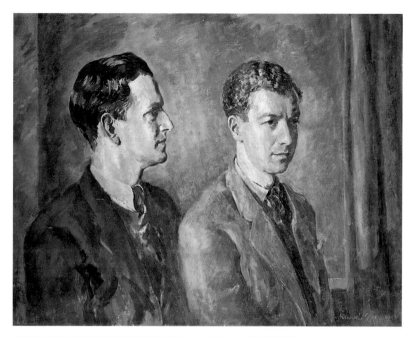

Peter Pears (1910–86); Benjamin Britten (1913–76) by Kenneth Green, 1943 (NPG 5136)
Oil on canvas, 715 x 969mm

this portrait reveals more about Britten's inner turmoil than he was probably either aware of or would have wished to reveal. In 1943, the pair of them were two years away from the triumphant premiere of Britten's opera *Peter Grimes* at Sadler's Wells, and five years from founding their festival at Aldeburgh. Pears was thirty-three at the time of being painted, and Britten was thirty.

They were, more importantly, newly back from four years in America. They had followed W.H. Auden there in 1939, and Britten had had to leave, among other things, the house on the Suffolk coast that he had just bought with a legacy from his mother. He had missed Suffolk and its particular seashore acutely – indeed *Peter Grimes* is based on the poems of the Suffolk poet, George Crabbe. And Britten was, in any case, a creatively driven and also conflicted creature all his life, especially about his sexuality.

But here they are together, these two musical greats – and definitely a couple, wearing blue shirts and informal jackets and ties. Pears is in handsome profile, Britten with his brow furrowed, looking both off-stage, as it were, but also inwardly. They have probably realised that this point in their careers, on the cusp of serious recognition and acclaim, is portrait time, but Britten doesn't look reconciled to the idea. He also

looks as if he wouldn't think of hiding his feelings, that any glossy emotional subterfuge wouldn't occur to him. You could say that the same effect could easily be achieved with a photograph, but a photograph would be more ephemeral, the capturing of a possibly unguarded moment, and this unmistakeable inner dialogue of unresolved thoughts was what Kenneth Green saw in him at every sitting. It was something that Britten couldn't hide. So this is a portrait of both realism and authenticity, showing a vulnerability and an intense inner focus that the sitter was entirely careless of – and was thus, touchingly, not a conscious participant in. It is also a psychological world away from the breezy deliberateness of Barbara Villiers.

Yet, over-arching all these nuances in motive or aspiration, there is something that runs through most responses to the suggestion or notion of a portrait. Almost nobody, however genuinely without vanity they are, seems able to resist having their portrait painted. It is, after all, an exquisite accolade, as well as being a peculiarly permanent, almost immortalising, memorial. It may sometimes appear a kind of salvation. Look at Sir John Lavery's portrait of Ramsay MacDonald,

painted just as the Depression ended his second term of office as Prime Minister and caused his expulsion from the Labour Party. Or, a portrait can be seen almost as a self-awarded laurel wreath. Look at Walter Sickert's admirable portraits of Churchill (who took lessons from him) and Beaverbrook. By his later years, Sickert was painting from photographs, rather than from life – he said it avoided the trouble of sittings or getting commissions – but neither of those powerful or impatient twentieth century titans seem to have been troubled by this expediency, no doubt because they knew that the finished results would be so indisputably arresting.

A portrait, then, can be the ultimate tribute, the final monument. It can also advertise, promote, manipulate, interpret, reveal and celebrate. It has a majesty photography can seldom achieve, and a significance. It is also, for any human being in search of connection, irresistible. Who else is going to look at the sitter's face as meticulously, as discerningly, and for as long at a time, as a painter of portraits?

Which leads me on, inevitably, to wonder about the particular motivation behind self-portraits … But that, of course, is another whole story.

BP PORTRAIT AWARD 2013

The Portrait Award, in its thirty-fourth year at the National Portrait Gallery and its twenty-fourth year of sponsorship by BP, is an annual event aimed at encouraging young artists to focus on and develop the theme of portraiture in their work. The competition is open to everyone aged eighteen and over, in recognition of the outstanding and innovative work currently being produced by artists of all ages working in portraiture.

THE JUDGES

Chair: Sandy Nairne,
Director,
National Portrait Gallery

David Dawson,
Painter and Photographer

Sarah Howgate,
Contemporary Curator,
National Portrait Gallery

Victoria Pomery,
Director, Turner Contemporary

Ali Smith,
Writer

Des Violaris,
Director, UK Arts & Culture, BP

THE PRIZES
The BP Portrait Awards are:

First Prize
£30,000, plus at the Gallery's discretion a commission worth £5,000.
Susanne du Toit

Second Prize
£10,000
John Devane

BP Young Artist Award
£7,000
Owen Normand

PRIZEWINNING
PORTRAITS

Pieter
Susanne du Toit

Oil on canvas,
1080 x 830mm

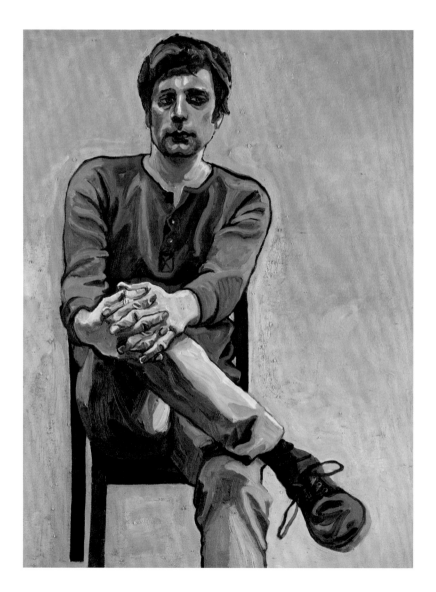

Winner of the 2013 BP Portrait Award, Susanne du Toit was born in Pretoria, South Africa where she graduated with a BA in fine art from her hometown university before obtaining an MA, majoring in painting and printmaking, at Massachusetts College of Art in Boston in 1989. Du Toit's time in America proved to be a turning point in her artistic development, leading her to jettison early experiments in abstract expressionism in favour of the figurative painting that she now practises.

'My tutors in Boston were confused about my subject matter; it seemed strange to them that I used such a solipsistic style coming from a country in such political turmoil, with so much to comment on,' she recalls. 'I became acutely aware of the significance of context to art, and that abstract art offered no relationship to context. It felt increasingly like a dead-end street.'

Moving to England in 1994, du Toit turned to portraiture after being 'blown away' by the *Glitter and Doom* exhibition of German art from the 1920s at New York's Metropolitan Museum of Art in 2005, in particular the Verist portraits of Otto Dix. She now lives in Berkshire, working across a range of media, including watercolour, etching and ceramics, and has exhibited at the Royal Academy and entered the Royal Watercolour Society open competition, for which she was awarded the Daler Rowney Prize in 2010.

Her winning entry in the BP Portrait Award, *Pieter*, is of her eldest son and was painted in oils over several sittings in her studio, where she allowed Pieter to find his own pose, with the condition that his hands would appear prominently in the composition. 'I have always found hands essential to communicating personality,' she explains. 'I look to the body to provide as much expression as the face.'

After transferring her initial pen-and-ink line drawings from a folio-sized sketchbook to the canvas, she finished Pieter's face in one afternoon, and his clothes during the next sitting, deliberately working quickly in order to keep the brushwork fresh. A neutral background, originally painted with more visible brush marks, was calmed down so that nothing would compete with the human figure.

The portrait is part of a series depicting du Toit's family and reflects the artist's move towards increasingly personal subject matter. 'Over the years, as I have become gradually distanced from my beginnings, my art has become an intensely personal experience, and that is where any value it has for other people will come from,' she says. 'In my view, I would measure the success of the painting in terms of evoking and communicating emotion. In this instance I know the sitter well, and I want to believe that I captured his inner life.'

The Uncertain Time
John Devane

Oil on canvas,
1720 x 2490mm

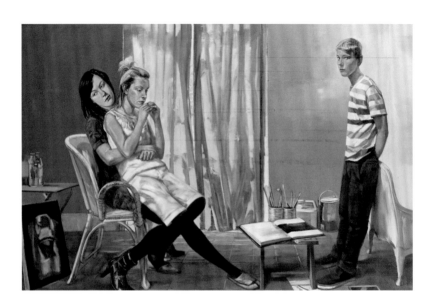

John Devane's second-prize entry portrays the artist's three children, Lucy, Laura and Louis, at their home in Coventry. Its title, *The Uncertain Time*, alludes to the siblings' transition from childhood to the cusp of young adulthood. 'My work is invariably based on my own life experiences; immediate friends and family are my subjects,' says Devane. 'Here, I was trying to convey something of the idea of three young people growing, developing through adolescence.'

The portrait was painted over a three-year period, a lengthy process that Devane ascribes to the demands of his job as head of design and visual arts at Coventry University School of Art and Design. 'I generally work a bit quicker, but this particular picture seemed to take for ever,' he says. 'In some ways I have adapted to painting in short bursts of activity, because of the day job. This can be frustrating, but at the same time it can allow for a sort of slow-burn approach.'

As the portrait took shape, that slow-burn approach allowed Devane to amend his original composition, changing the siblings' poses and gazes as the dynamic within the family shifted over the years.

'Louis's pose changed dramatically, from an earlier version where he is younger and was standing in profile looking at Laura who returned his gaze,' he notes. 'Now, Louis confronts the viewer, whilst the girls are each pre-occupied, distracted in some sense. Lucy and Laura have a close bond. I tried to show a physical connection that is to do with Lucy being literally physically supportive to Laura who is too big to sit on her lap. The pose allowed for an interesting juxtaposition of limbs.'

Devane graduated with a BA in fine art from Liverpool Polytechnic and an MA in painting from the Royal College of Art. Between his studies, he was commissioned by the Imperial War Museum to portray Britain's military presence in the south of Cyprus during the late-1970s conflict. The ensuing paintings – some on paper, others on canvas – are now in the Museum collection.

He has since exhibited widely in the UK and abroad, including in the 1995 BP Portrait Award, and as a finalist in the Garrick Milne Prize in 2005. Most recently, he held a solo show comprising his figurative portraits at Gallery 150 in Leamington Spa.

'It doesn't really matter how many figurative paintings have been made before, because for the contemporary figurative painter, it's always a new challenge,' he remarks. 'Modernist rhetoric tends to reinforce the idea of art as being about constant innovation. Post-modernism has largely debunked that idea, so there is no reason why figurative art should not be relevant or vital.'

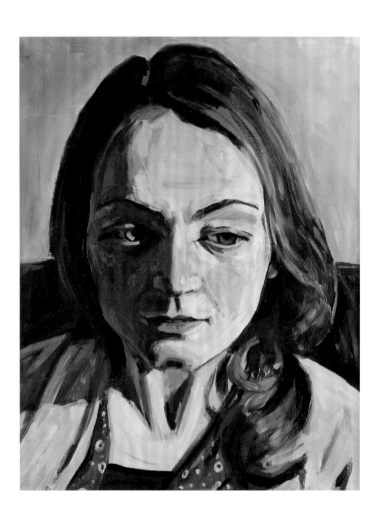

Recipient of the Young Artist Award, Owen Normand grew up in the north of Scotland where his creative ambitions were encouraged at a young age when the Scottish artist and playwright John Byrne bought one of his earliest works. 'I was about fifteen and had entered the painting for an open exhibition,' recalls Normand, now aged twenty-eight. 'I thought that if somebody whose work I admired had also appreciated mine, there must be something worthwhile in my art.'

Normand's formal training began at Leith School of Art in Edinburgh, before he studied illustration at the Edinburgh College of Art, graduating in 2008. He relocated to Germany three years ago and his winning portrait depicts his girlfriend Hannah in her Berlin bedroom. The title, *Das Berliner Zimmer* (*The Berlin Room*), is the name for a long, dark room facing into an inner courtyard with just a single window, an architectural feature unique to the city.

'The painting was inspired by Hannah's connection to Berlin, particularly through her grandmother, who moved to the city in the 1930s as an actress and still lives there today,' he says. 'Hannah has such a striking face – the lighting in this pose suited it particularly well, creating versatile geometrical shapes through shadows. She has a very vivid imagination and is sometimes lost in her own thoughts and I wanted to paint her thinking or remembering. The expression I captured is contemplative and can be read in different ways, leaving the viewer to fill the painting with their own imaginings.'

In preparation, Normand painted seven studies of the sitter in different poses. The main portrait was painted from two sittings from life, over the course of two weeks. 'During the first sitting I began with an under-painting in acrylic, blocked in everything as quickly as possible, and then started working in oil. During the second sitting I worked in oil and made adjustments, focusing on capturing the right expression.'

Normand's client work ranges from commissioned paintings to website and book illustration, while he also pursues his own portraiture projects, working in a variety of materials, such as brush and ink or charcoal. He is currently completing a series of night-time paintings of lone figures in Berlin.

'I have always thought that observational skills in art are incredibly important, beautiful and impressive,' he remarks. 'However, more and more, my philosophy has been that these things alone don't make a work of art. It's the expression, emotion and creativity that an artist puts into their work that makes an artwork come to life and evokes an emotional response from the viewer.'

SELECTED
PORTRAITS

Power of moment
Zahra Akbari Baseri

Acrylic on canvas,
340 x 240mm

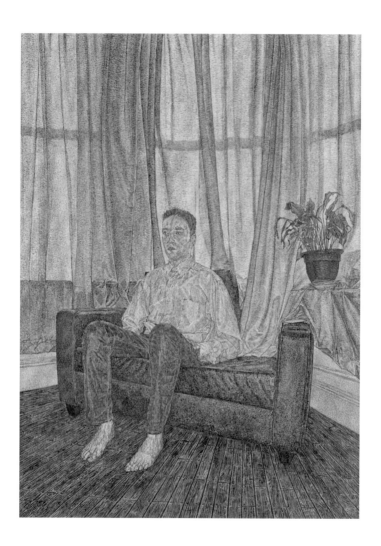

Self-portrait
Daniela Astone

Oil on linen,
1600 x 1300mm

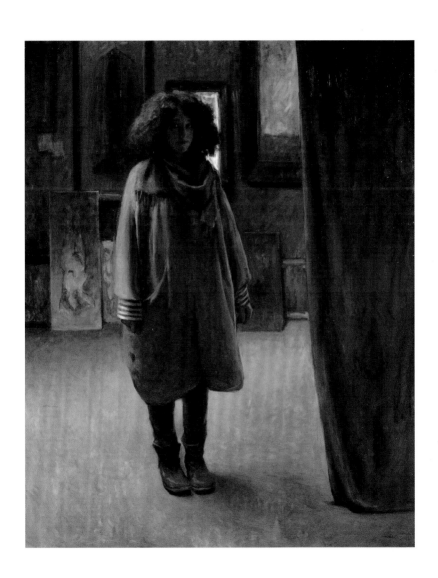

Alastair Campbell 'All In The Mind'
Paul Anthony Barker

Oil on canvas,
457 x 355mm

Ex-member of Philharmonic Orchestra
Stanislav Buban

Oil on canvas,
400 x 400mm

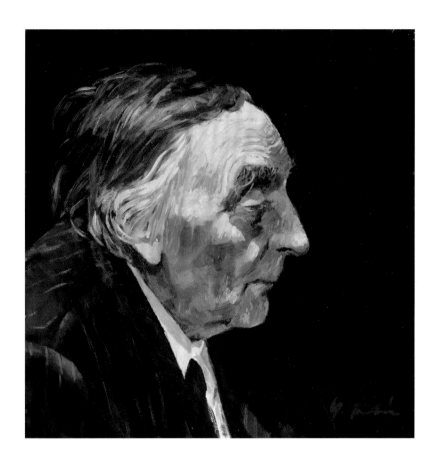

Conversations
David Caldwell

Oil on board,
1650 x 1900mm

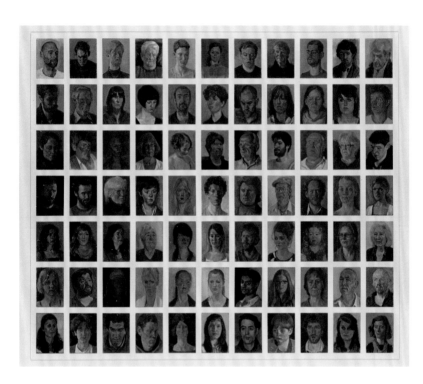

Self-portrait as a Cyclist
Comhghall Casey

Oil on linen,
560 x 460mm

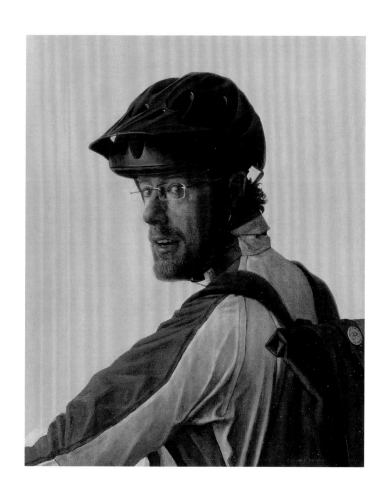

Josh
Fred Clark

Oil on board,
415 x 340mm

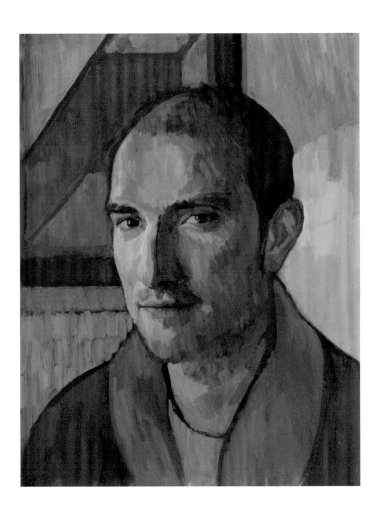

Net no.10
Daniel Coves

Oil on board,
1000 x 1000mm

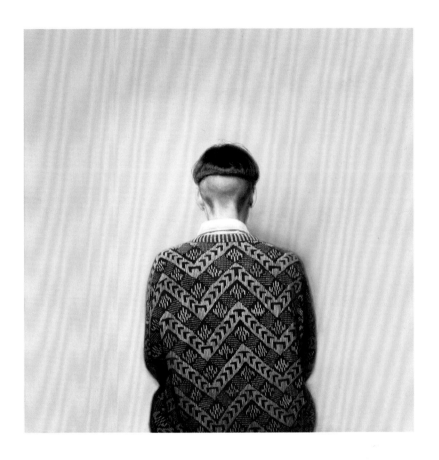

Self-portrait
Ian Cumberland

Oil on linen,
2000 x 1400mm

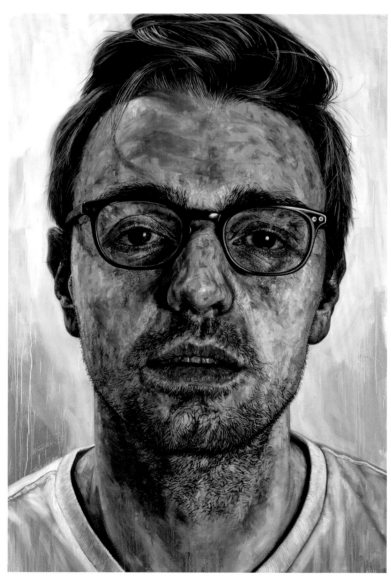

In Memory
Saied Dai

Oil on linen on panel,
460 x 300mm

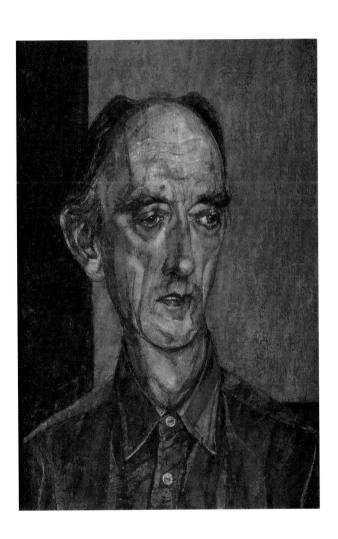

Takami Horikoshi
Colin Davidson .

Oil on linen,
1270 x 1170mm

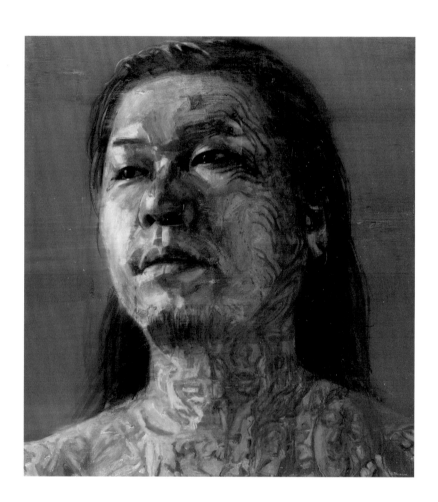

Getting ready
Eric De Vree

Oil over acrylic on panel,
510 x 390mm

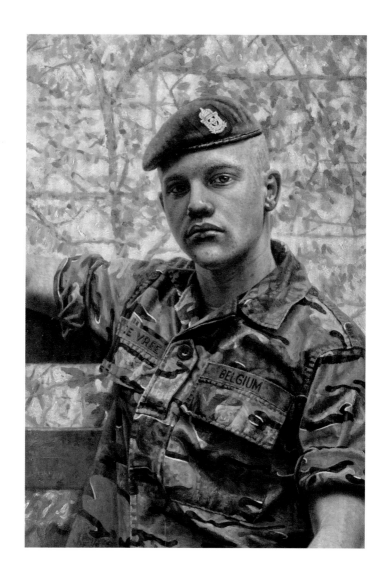

Kirsty
Clara Drummond

Oil on panel,
400 x 210mm

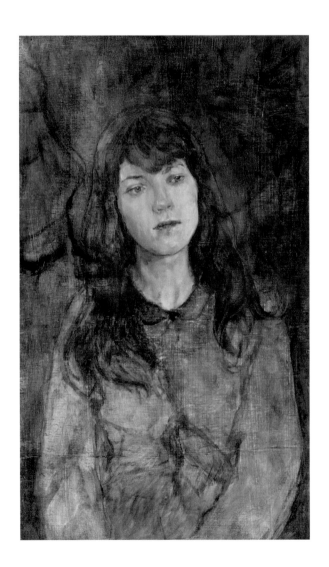

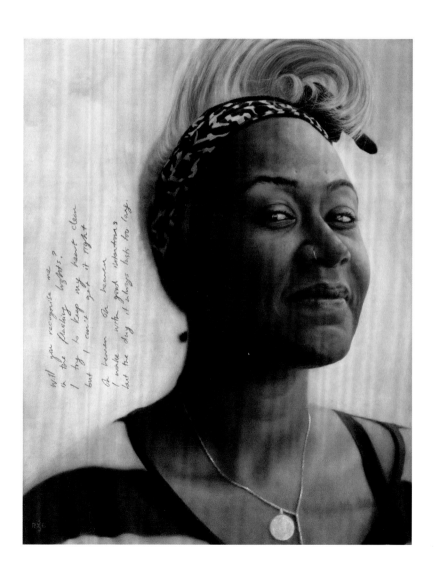

The Rose and the Bee
Mark Fairnington

Oil on panel,
300 x 250mm

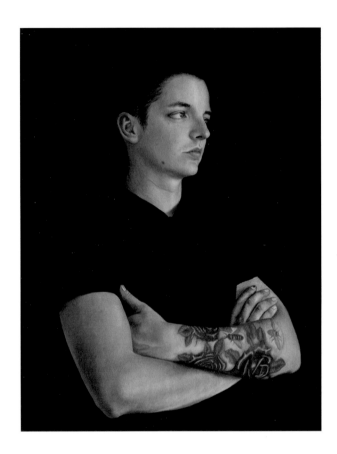

Self-portrait
Mark Giangaspero

Oil on wooden board,
400 x 480mm

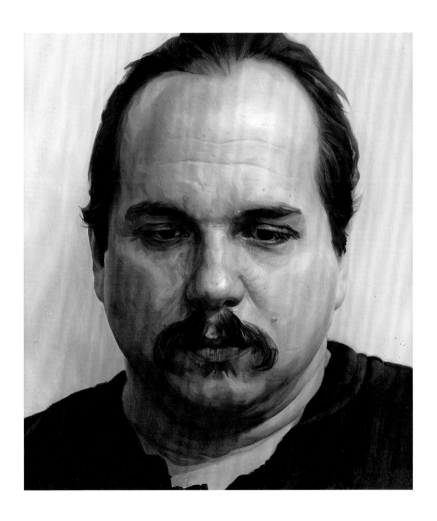

Aureta Thomollari at
Fashion Week – NYC
Vincent Giarrano

Oil on linen,
406 x 508mm

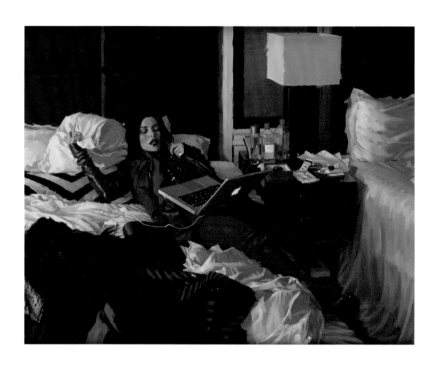

Wessel, as a work in progress
Franny Golden

Oil on canvas,
1680 x 1290mm

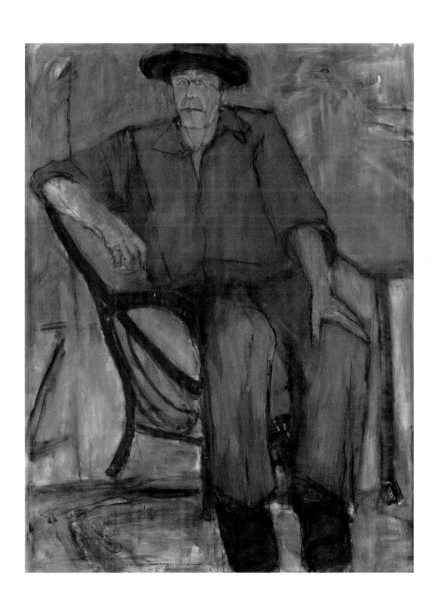

Teresita in a coat
Gonzalo Goytisolo

Oil on canvas,
720 x 620 mm

My Father
Julie Held

Acrylic and oil on canvas,
1525 x 915mm

The Shadow of Life
Lucy Jones

Oil on linen,
1800 x 1200mm

Heterochrome – Fraser & his self-portrait Oil on panel,
Greg Kapka 410 x 370mm

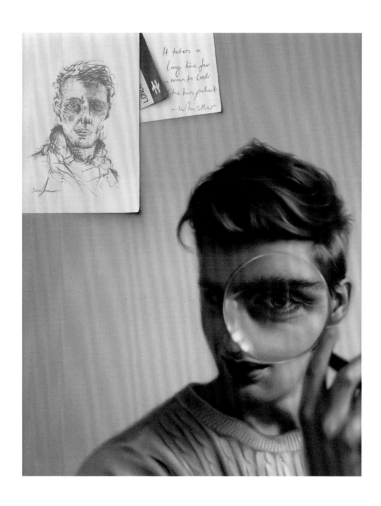

Stephen Mason, Deptford Boy
Alison J. Kelleher

Oil on plywood,
300 x 200mm

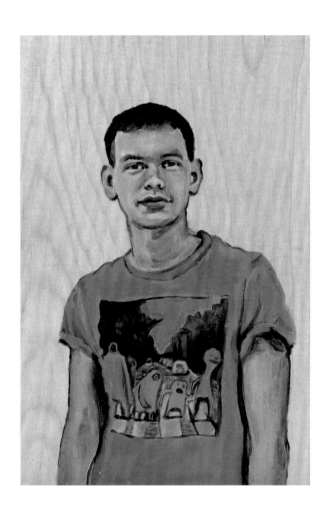

Cocorita
Antonio Laglia

Oil on canvas,
725 x 620mm

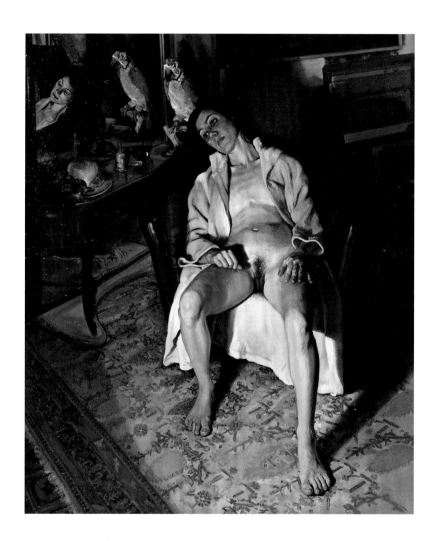

My Diary No. 5
Miseon Lee

Oil on linen,
1250 x 620mm

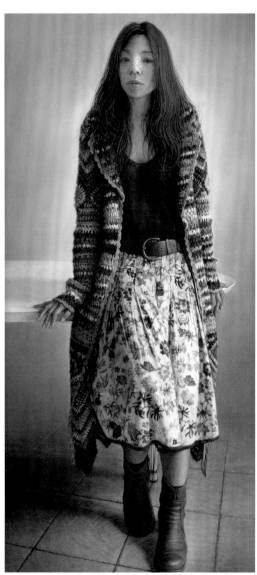

Cliff
Sophie Levi

Oil on canvas,
500 x 400mm

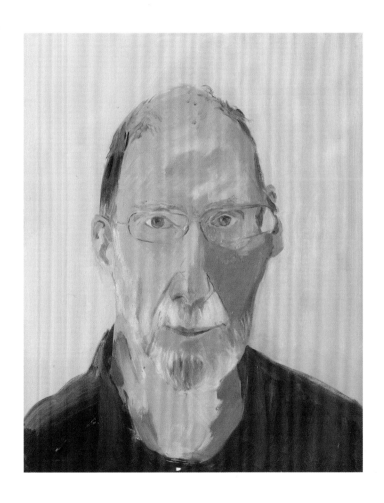

Zuzana in London
Hynek Martinec

Acrylic on canvas,
1300 x 1100mm

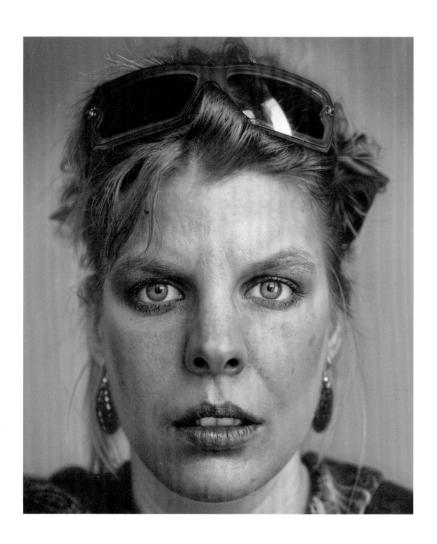

Chomsky
Raoul Martinez

Oil on canvas,
1473 x 737mm

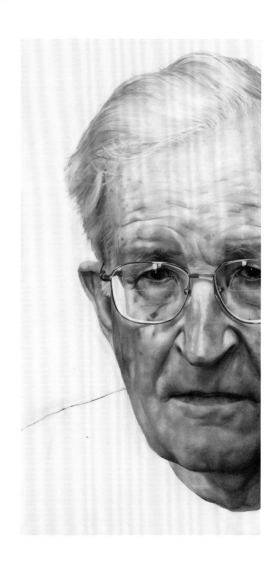

Bird's Eye View
Benito Mayor Vallejo

Oil on linen,
1500 x 1800mm

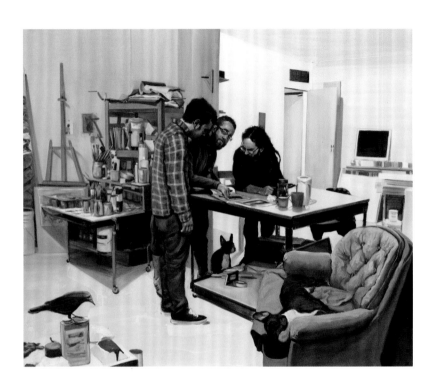

Self-portrait
Ewan McClure

Oil on board,
285 x 230mm

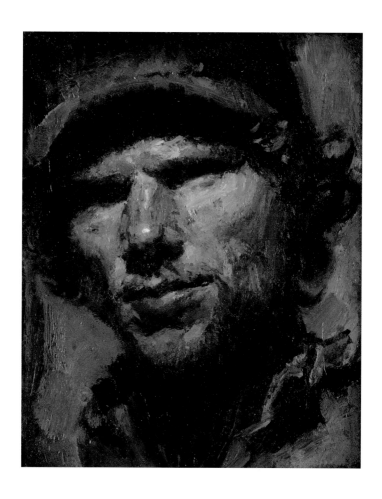

Diana, becoming
Stephen Murphy

Oil on canvas,
406 x 305mm

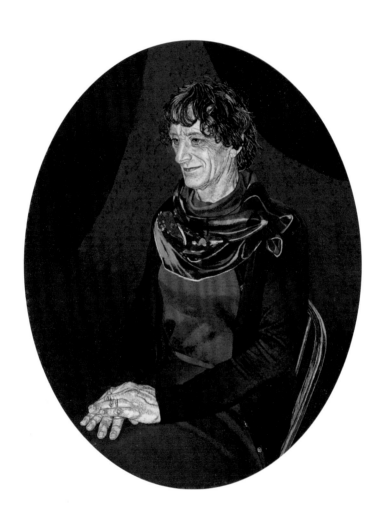

Portrait of Ronald Fuhrer
David Nipo

Oil on canvas mounted on board,
1000 x 575mm

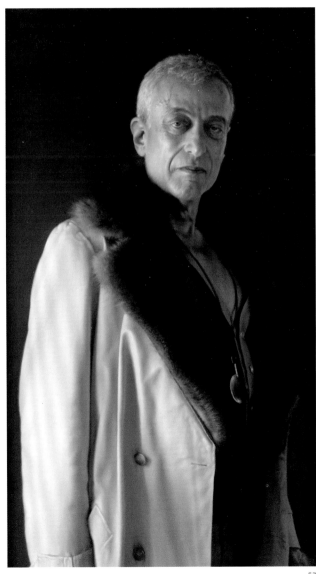

The Roadhouse Crew
Tony Noble

Oil on linen,
1400 x 1660mm

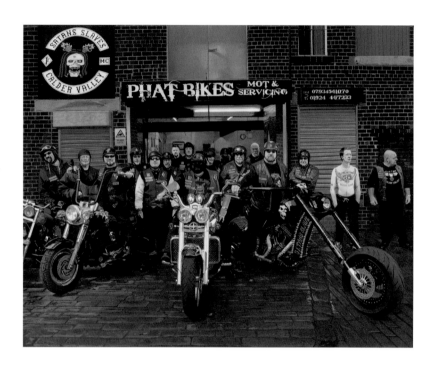

The Adoration of Frida
Abe Odedina

Acrylic on board,
1540 x 1240mm each

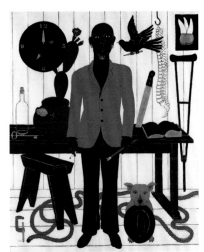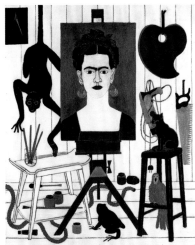

Ved Mehta
Paul Oxborough

Oil on linen,
711 x 533mm

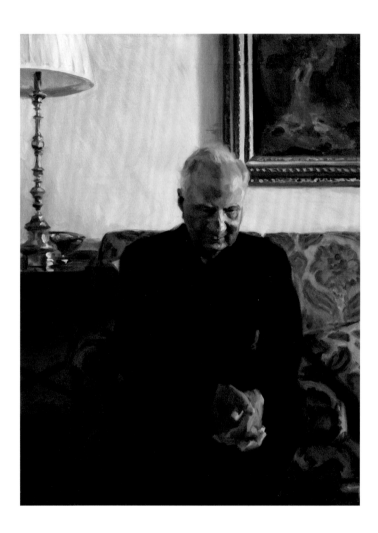

Portrait Sketch of Charles
HK Park

Oil on canvas,
762 x 610mm

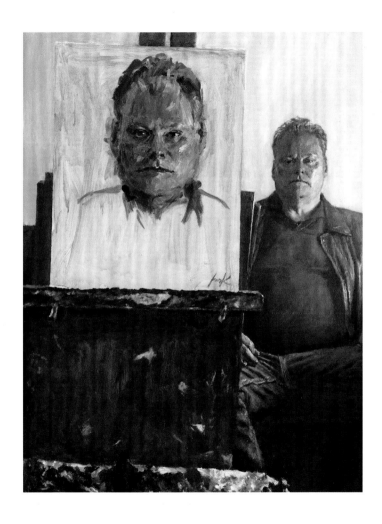

Self-portrait with Lace Collar Oil on panel,
Sophie Ploeg 240 x 300mm

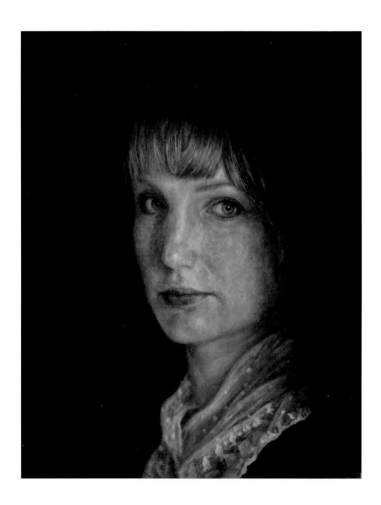

Shinjuku, Tokyo
Carl Randall

Oil on canvas,
650 x 1300mm

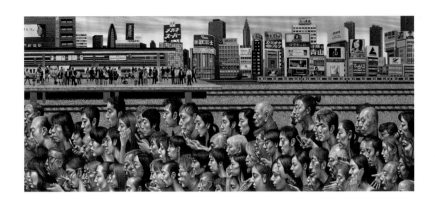

Portrait of Sean
Jennifer E. Renshaw

Oil on wood panel,
203 x 254mm

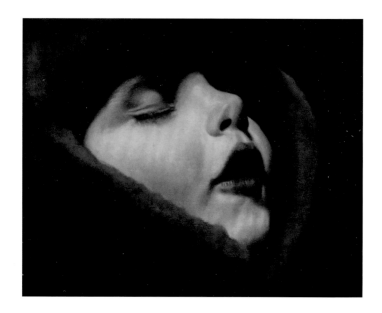

Laura in January
Laura Robertson

Oil on canvas,
420 x 594mm

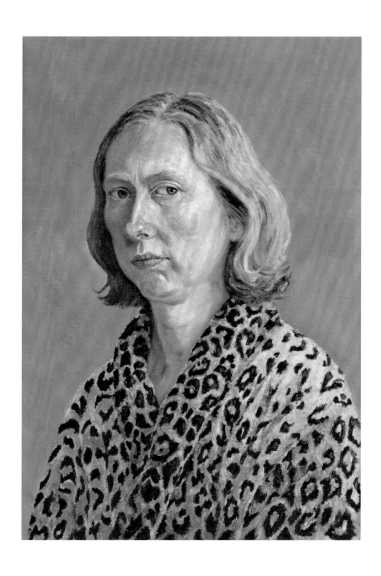

Inner dialogue
Jamie Routley

Oil on canvas,
1230 x 1020mm

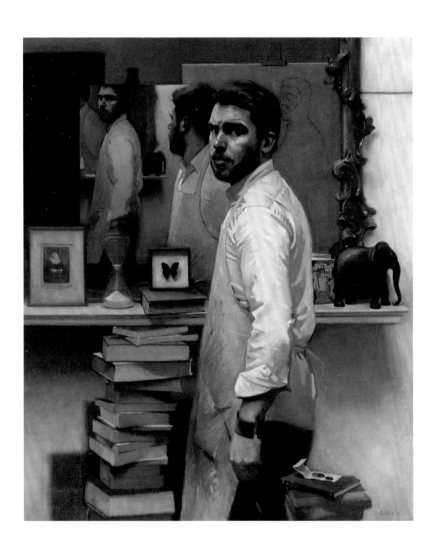

Kristy
Geert Schless

Oil on wooden board,
1000 x 650mm

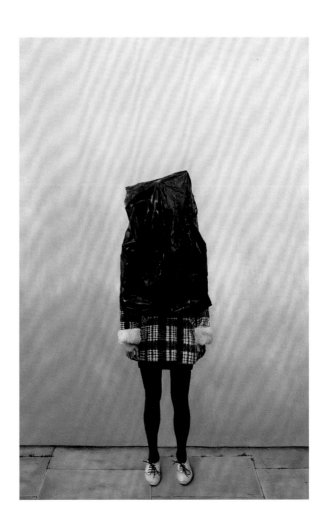

Mrs Damon and Mrs Healey
Teri Anne Scoble

Oil on canvas,
500 x 760mm

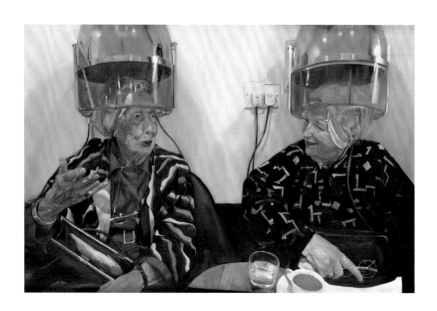

Kholiswa
Lionel Smit

Oil on Belgian linen,
2300 x 1650mm

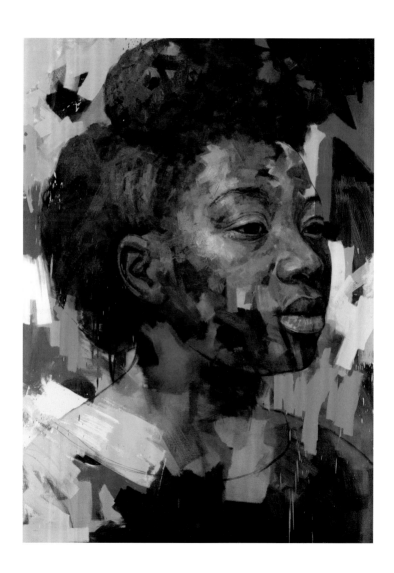

The Home Economics Room
Blaise Smith Arha

Oil on gesso panel,
1220 x 1220mm

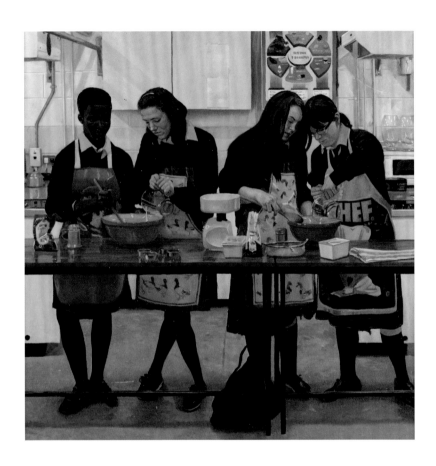

Self-portrait with Clown Face
Lisa Stokes

Oil and graphite on canvas,
1525 x 1050mm

Craig Eden
Benjamin Sullivan

Oil on canvas,
1040 x 540mm

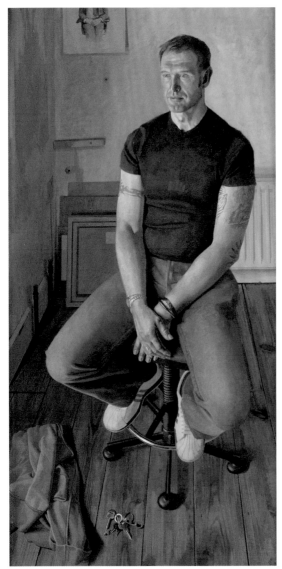

Portrait of a Young Painter,
Vanessa Hodgkinson
Alberto Torres Hernandez

Oil on gesso panel,
270 x 260mm

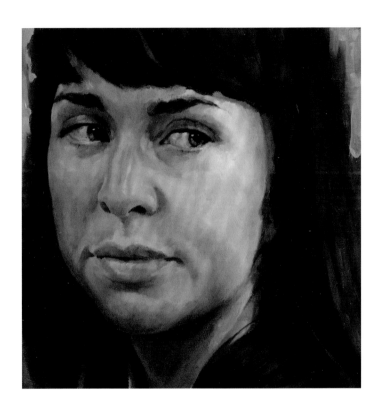

Drummond Money-Coutts
– The Magician
Agnes Toth

Oil on canvas,
785 x 1160mm

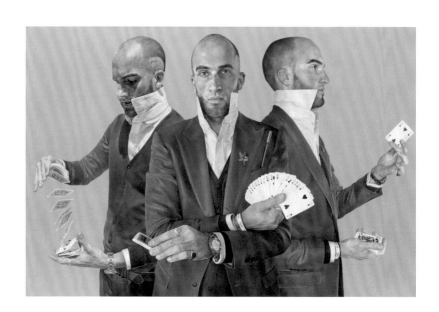

Rodney and Doreen Turvey (with Clara)
Simon Turvey

Oil on board,
507 x 405mm

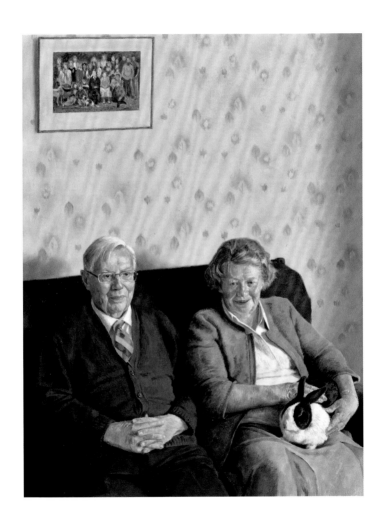

Philip Glass
Daan van Doorn

Oil on polyester on board,
1730 x 1370mm

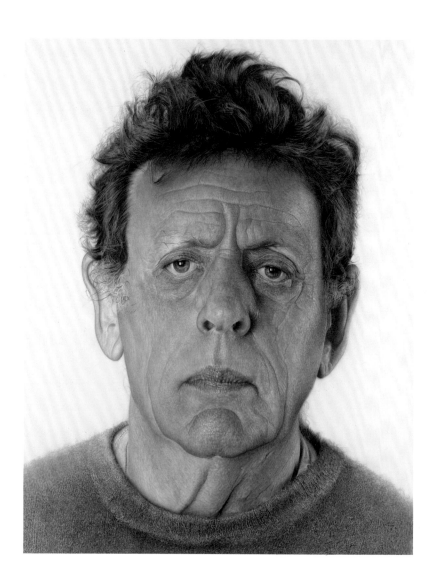

Pamela Newel Sellers
Leslie Watts

Egg tempera on panel,
304 x 304mm

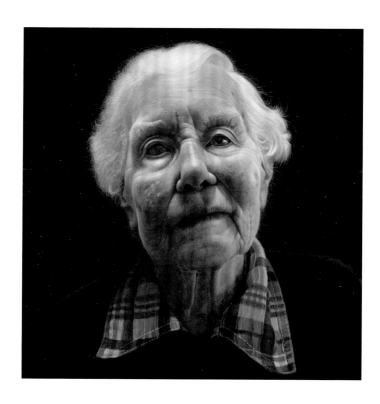

BP TRAVEL AWARD 2012

Each year exhibitors are invited to submit a proposal for the BP Travel Award. The aim of this award is to give an artist the opportunity to experience working in a different environment, in Britain or abroad, on a project related to portraiture. The artist's work is then shown as part of the following year's BP Portrait Award exhibition and tour.

THE JUDGES

Sarah Howgate,
Contemporary Curator,
National Portrait Gallery

Liz Rideal,
Art Resource Developer,
National Portrait Gallery

The Japanese woodblock print artist Ando Hiroshige (1797–1858) made prints depicting the places and people of his day. In 1832, he travelled along the Tokaido Highway, an old trading route that ran from Tokyo to Kyoto, producing a series of woodblock prints showing the people he met and the landscapes he experienced along the path. The prints now serve as a valuable artistic document of life in Japan at that time, forming an important part of the country's rich cultural heritage.

In June 2012, 180 years after Hiroshige made the journey, I travelled the route in order to make portraits of the people and their environments as they exist today. I encountered a great variety of people and places on the Tokaido Highway: a cross-section of old and new Japanese society, from salary men in office blocks to farmers in rice fields. The journey started in the bustling, vibrant capital city of Tokyo and, drawn to its densely crowded streets, I painted hundreds of residents one by one, directly from life (shown in *Tokyo*). The depiction of strangers in crowded public spaces is related to my ongoing interest in urban alienation – the idea of people sharing the same close physical space, but mentally existing in separate worlds – a phenomenon that can be seen in large cities such as Tokyo. At first glance, the solid clustered mass of

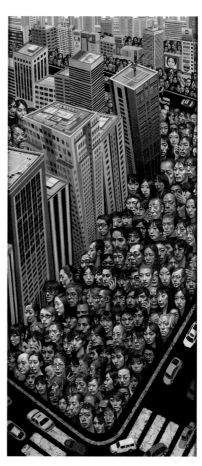

Tokyo by Carl Randall, 2012
Oil on canvas, 1450 x 650mm

faces in the painting resembles one living organism, but upon closer inspection the individuality of each face becomes clear. I wanted to see the eye oscillate between the

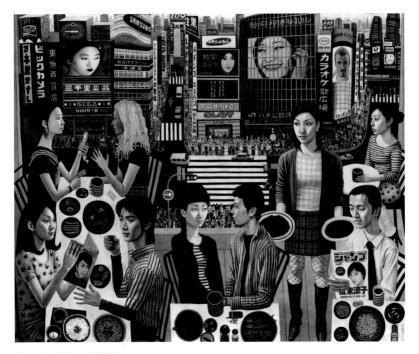

Shibuya by Carl Randall, 2013
Pencil and ink on paper, 1260 x 1500mm

two. The largest work, *Shibuya*, depicts the pop-culture, street signs, advertisements and gigantic outdoor television screens of an area in Tokyo popular with young people, and *Uguisudani* portrays the love hotels and neon signs of one of the city's red-light districts. Visiting other major cities along the route, such as Yokohama and Nagoya, I painted other features of modern Japan such as salary men, sushi restaurants and department stores.

As the highway moves out of cities and into rural areas, elderly rice farmers work their fields, their backs permanently bowed, skin leathery

and wrinkled from a lifetime of farming. While visiting these areas, I also had the opportunity to see aspects of traditional Japanese scenes, hot springs, fireflies and red autumn leaves.

Finding the modern and urban ever present in the rural, with old and new often sitting side by side, I included elements of the industrial within images of nature: bullet trains and motorways cut through mountains; telegraph poles and tower blocks dot the landscape and tetra-pods line the coastline. These, and other motifs, such as the mobile phone, are used to place the images in the

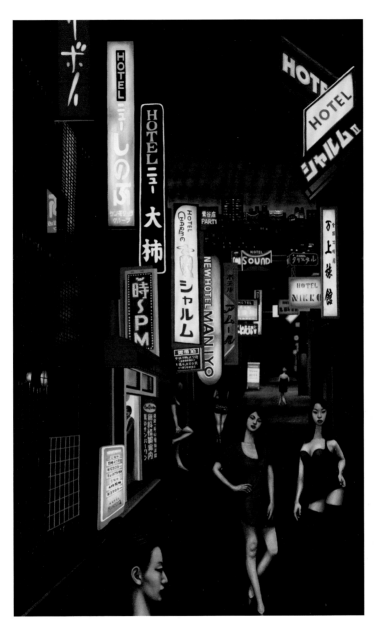

Uguisudani by Carl Randall, 2012
Oil on canvas, 820 x 500mm

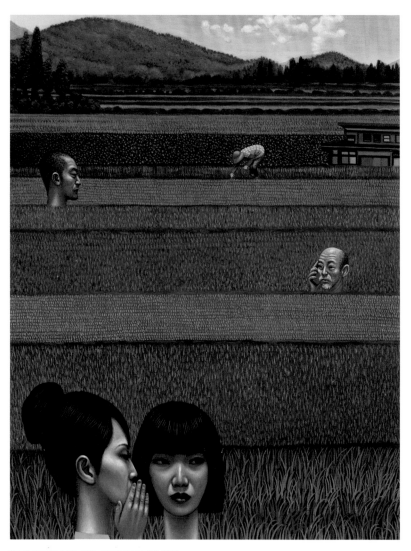

The Rice Farmers' Daughters by Carl Randall, 2012
Oil on canvas, 410 x 318mm

contemporary world, while also helping to avoid nostalgic depictions of historical Japan. This seemed particularly important in a place such as Kyoto, the final stop of the journey, a city associated with all things traditionally Japanese, and occupying a strong place in the Western imagination. I would hope that my portrayal of familiar

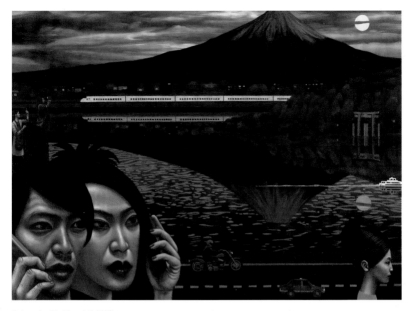

Hakone by Carl Randall, 2012
Oil on canvas, 297 x 410mm

Japanese icons such as Sumo wrestlers, Kabuki, Geisha, Zen gardens and Mount Fuji have here been presented in a slightly different way.

I should offer a brief description of my working process. Before starting the project, I decided not to aim to faithfully document the exact locations on which Hiroshige's prints were based, as I felt a literal approach would better suit photography (the route has indeed already been visited by photographers and historians, comparing vantage points in Hiroshige's prints with those that exist now). Instead I used the project as a framework upon which to create more imaginative portraits of modern Japan. The

result is composite images guided by memory, personal feeling and intimate observations, portraying the atmosphere of a place and its people rather than exact physical characteristics.

While making my paintings, I avoided referring to Hiroshige's prints, so as not to be overly influenced by his visual language. However, certain aspects of his working process are reflected in my own. For example, rather than finish the works on location, I collected information that I used later in the studio. The A3 size of the fourteen smaller paintings is similar to that of Hiroshige's original prints, and I sometimes tried to suggest stories through the relationship between figures and environment (echoing his narrative-based prints).

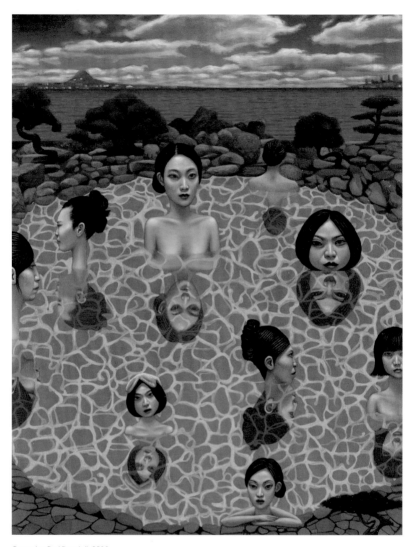

Onsen by Carl Randall, 2012
Oil on canvas, 410 x 318mm

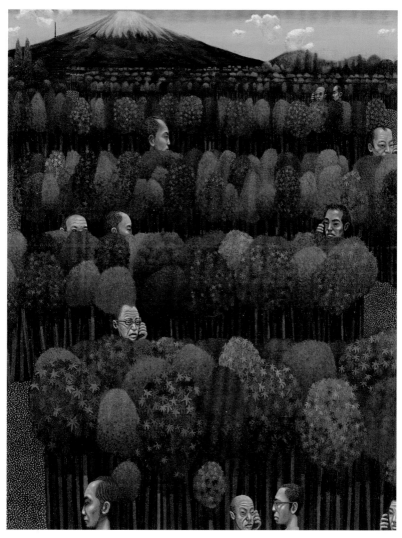

Aka-Fujii by Carl Randall, 2012
Oil on canvas, 410 x 318mm

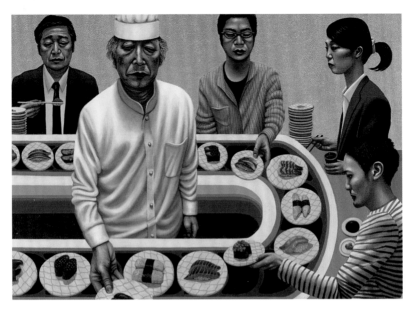

Sushi by Carl Randall, 2013
Oil on canvas, 290 x 410mm

Similar to myself, Hiroshige often exaggerates or distorts reality to suit his pictures. For example, in one print he portrays men climbing up a steep incline (seemingly to depict the struggle of walking against monsoon rain), while the actual location is flat with no slopes; in another he invents mountainous islands to add compositional interest; and in others geographical features are exaggerated for dramatic effect. A similar spirit can be found in my work, taking advantage of the distortions of scale, space and colour afforded by the painter. These paintings provide a view of Japan as seen through the eyes of a visiting European painter – the distortions created by painting through a foreign lens being an important factor in shaping them.

This unique and exciting opportunity allowed me to develop my interest in portraiture and Japan, while following in the footsteps of a great artist. I felt privileged to be the first portrait painter to respond to this subject matter, and I would hope that this exhibition generates further public interest in Hiroshige and the fascinating country to which he belongs.

I would like to thank the National Portrait Gallery and those involved with the project in Japan for their help.

ACKNOWLEDGEMENTS

Many congratulations are offered to all the artists in the exhibition, and especially to the prizewinners, Susanne du Toit and John Devane, and to Owen Normand, the winner of the prize for a younger painter. As always, I am grateful to all the artists who decided to enter the 2013 competition.

Special thanks go to my fellow judges: David Dawson, Sarah Howgate, Victoria Pomery, Ali Smith and Des Violaris. They gave close and scrupulous attention, and were thoughtful in their judgements, all the way through the two days of selection. I should also like to thank the judges of the BP Travel Award: Sarah Howgate, Liz Rideal and Des Violaris. I am especially grateful to Joanna Trollope for her excellent contribution to the catalogue – she has shown a close attentiveness to portraiture over many years. I am very grateful to Richard McClure and Andrew Roff for their editorial work, Anne Sørensen for designing the catalogue and to Michelle Greaves for her overall management of the 2013 BP Portrait Award exhibition. My thanks also go to Pim Baxter, Stacey Bowles, Nick Budden, Neil Evans, Tanja Gangar, Ian Gardner, Justine McLisky, Catherine Mailhac, Ruth Müller-Wirth, Vivienne Reiss, Jude Simmons, Christopher Tinker, Sarah Tinsley, Denise Vogelsang, Ulrike Wachsmann and many other colleagues at the National Portrait Gallery for all their hard work in making the competition and exhibition such a continuing success. My thanks go, as in previous years, to The White Wall Company for their contribution to the high quality management of the selection and judging process.

Sandy Nairne
Director, National Portrait Gallery

INDEX